Foreword

Viewing a film by T.J. Wilcox is an intimate and sensual experience reminiscent of childhood cine screenings: the evocative clicking sound of the projector and the flickering magic show on the screen. At the end of the 20th century, Wilcox's films are tiny love poems to the dominant medium of the century, they are moments of pure cinematic experience placed in a gallery for contemplation. The films make demands on the viewer - meaning has to be teased out, where you are and what you are looking at is not always clear, the familiar has become strange. Just when the going is getting tough however, Wilcox charms with a section of home-made animation, providing an infusion of winsome joy, a celebration of home-crafted artefacts. Each of Wilcox's films is a labour of love, capturing images frame by frame, transferring from film to video and back to film, they perfectly mirror the obsessive behaviour of their beloved subjects.

The ICA is pleased to be the first public gallery to present a solo exhibition of films by T.J. Wilcox and we would like to express our thanks to all those who have helped us mount the exhibition, especially the artist T.J. Wilcox, Gavin Brown, Kirsty Bell, Ian Hunt, Douglas Fogle and Robert Miniaci.

Emma Dexter
ICA Director of Exhibitions

Commentary
by Ian Hunt

The Escape (of Marie-Antoinette) (1996)

RINGMASTER: Une révolution... authentique!
CHORUS OF WOMEN ACROBATS: [juggling] ... AUTHENTIQUE!
(*Lola Montés*)

It starts in silence, without warning or formalities. Horsemen ride from left to right before a static camera; an old film in blueish TV light. A still, vertical figure is lifted upwards as though from a stage trapdoor, and then springs into movement, running away from us towards the arriving coach. There is something of the circus about what we see, and the distance from which we see it. The film is slowed, but one's eyes still cannot understand what is happening; subtitles, none too clear, demand that we read as well as attend to what's happening. 'Here, ladies and gentlemen, is the truth... / the whole truth of the extraordinary life...' After the succession of arrivals into the field of view from the left, there is a sudden switch to camera movement on the up-down axis – one of the formal tropes of Wilcox's film. A blurry white-clad figure of a queen-princess-good fairy comes into view. The camera movement is disorientating; against a dark background, the figure at first appears to be moving vertically of its own accord, floating upwards. A cut takes us closer, but not close enough to read much of the face. What we see has been refilmed from a TV monitor, the edge of which is clearly visible. As are the horizontal streaks of pure black and white at the base of the image that indicate someone's watching a video. You even catch sight of his reflection, this matinee video-watcher.

 Title cards, in copperplate, fill the screen: The Escape / of Marie Antoinette. Did she 'escape', one wonders? Fidelity to T.J. Wilcox's attention to detail obliges the commentator to point out that the film is elsewhere titled The Escape (of Marie Antoinette), which makes one hesitate over the nature of that 'escape'. But then...

the artifice by which a shot-by-shot commentary pretends to keep pace with a film must allow itself to be broken for the occasional interpretative aside.

We see her face in close-up, pushing her hands together under her chin in the gesture of a happy child. She is in W.S. van Dyke's *Marie Antoinette* (1938), accounted as one of Norma Shearer's better performances, though somehow she lacks the mystery of the Queen in the first sequence. (What did that first sequence show – escape, ambush; or the eye's failure to keep pace even with slowed movement?) From Versailles we move to Notre Dame, seen from the bank of the Seine, and the Paris crowds. The film is announcing itself again: 'Ladies and gentlemen... In this little box I'll show you a new world. Step right up. Put your eye to the miraculous keyhole, the mirror of history...'. It could all be tricksy – the box of the TV, filmed and projected, claiming the space of the peep-show. But there is an innocent aspect of any filmgoer that hopes to be enchanted, and is enchanted by this experience. In slowing down and silencing the film extracts, mysteries are being made that the eye would not normally discover; film is revealing the unconscious we secretly hope it to have.

The showman's female assistant places a lighted candle vertically downwards into the peep show. A trick of vision is never so effective as when you see exactly how it's done. There are hints of colour; we are perhaps no longer watching an historical film of the 1930s but a knowing romp from a more recent decade. There is another historical point to work out, which is when the story is actually set. 'Look at good King Louis XVI and his queen...'; a period of royalist reaction rather than revolution, it seems; a crowd hungry for sentiment, entertainment and scandal. Our eye is pressed to the miraculous keyhole. Again, as in the first sequence, there is a descending motion as the figure of the Queen appears, a paper cut-out *deus ex machina* from above. 'Notice... the Queen's sumptuous attire!'.

And then something odd happens. We have gone through the miraculous keyhole; excited harpsichord music breaks the silence, to mark the transition. At a fashion show a figure runs into view in a sumptuous chevron striped dress, her heavy plaits swinging and cheeks dark with rouge. It's a fantastic sight; she darts from one side of the runway to the other, swirling the fabric. She turns and her dress fills the screen, a swoony moment. A cut you hardly notice substitutes another dress, which is flounced; and in slow motion appears to move of its own volition, pulsing with its own life. Sex for the eye.

The clothes are by John Galliano, from an *aprés nous le déluge* styled collection on the theme of flight from mobs. One model wears wings on her head, like Mercury; though the heavy plaits could also resemble haute couture Red Indian. Knowing ostentation like this, to be consumed from afar, cannot often delight. But the dramatic device, to enter, fleeing, is magnificent. It breaks fashion show conventions, but perhaps can be allowed to recall something deeper.

'Once people ran from dangers that were too desperate to turn and face, and someone running after a bus unwittingly bears witness to past terror. Traffic regulations no longer need allow for wild animals, but they have not pacified running. It estranges us from bourgeois walking. The truth becomes visible that something is amiss with security, that the unleashed powers of life, be they mere vehicles, have to be escaped'.
(*Minima Moralia*, Adorno)

Are 'the unleashed powers of life' visible in that pulsing dress? I'd suggest they are - and that in this sequence T.J. Wilcox has strangely honoured the hopeless daring of the Queen who acted in plays by Beaumarchais at the Petit Trianon at Versailles, and was such a liberated dresser.

It is a jolt to be brought back to the peep-show figures being lowered into the field of view. Balconies and baying crowds follow: 'Come on out, Great Harlot!'. The next sequence is another homage to vigorous lateral movement from left to right, as an epauletted man runs to find the Queen. But there's no time for this visual enigma, its lacy veils and shadows indicating a mature cinematic style. 'If they stop, it's a riot, if they continue, it's a revolution,' read the subtitles. 'If they continue, they'll spoil the greenhouses'. It's one of the images that T.J. Wilcox has had enlarged from the film as a separate print; and the sequence seems to show the face of the first Queen we saw.

The flight of the royal family towards Belgium takes us to the birth of cinema at the fairground, in that a simple stop-frame animation is used: a gold carriage with unturning wheels, strangely realistic horses (drawn from Muybridge photographs) and drawn trees scrolling past on a repeat one can never quite catch out. It also lasts calculatedly too long; you start to wonder when something will happen. But the music finally stops. The silence of the final sequence is eloquent, and catches you out. Film deaths can be silly, but you don't take your eyes from them. The face of past happiness is superimposed on the face that has been led to the guillotine. Words are spoken that we can't hear or read; she is leaving us. The guillotine is the last of the many things in the film that move on a vertical axis. As it is winched up the film slows even more, allowing us for a brief moment to see stilled the individual frames from which the eye composes the illusion of movement.

The greenhouses? They were in Bavaria not Versailles. The 'revolution' referred to in the borrowed footage was a later one. The shimmering beauty of that particular queen belonged to Lola Montés, the famous courtesan and the subject of Max Ophuls' great film from 1955, in which she re-enacts her rise and fall at a circus in New Orleans and watches her life pass before her. It's the film I suspect T.J. Wilcox is really inspired by, in its extraordinary use of camera movement and its ability to make its audience reflect on fantasy as well as experience it. The story also reflects back vividly onto that of Marie-Antoinette, the Queen who did not understand how she gave the impression of behaving like a king's mistress.

Wilcox's refilming of the circus sequence from *Lola Montés* has given it the aura of the earliest films, and his inclusion of her face lends a mystery not to be found in that of Norma Shearer. But knowing how a trick is done is very different from the strangeness of what one sees as it's actually moving before one's eyes.

The Death and Burial of the First Emperor of China (1997)

Oversold contemporary cinema is not often capable of generating a child-like curiosity and excitement, but other forms still can; televised accounts of archaeological finds, for example. Wilcox's second film, captioned in Chinese and English, tells of the excavations east of Xi'an, Shaanxi province, where in 1974 peasants digging a well found part of the terracotta army guarding the First Emperor, the founder of the imperial system and the initiator of many economic and social reforms.

The wit of this film lies in having chosen a figure so much mythologised in Chinese historical writing, who was revealed by this discovery to have been if anything a more complete and well organised despot, if that's the right word, than anyone had expected. The film focusses on telling some of the fantastic *truths* about the tomb (in a suspiciously flat style) while making a visual evocation of them that playfully assembles all kinds of appropriated footage, as well as animation. There are also hand-held sections – like the opening sequence of Mann's Chinese Theater, Los Angeles; or the views of constellations painted on a high ceiling (New York's Grand Central Station), which are used to evoke early descriptions of the interior of the unexcavated burial mound. 'More than 70,000 conscripts labored there to realize, in miniature, the Emperor's vision of the world, made to orbit his body forever'. T.J. Wilcox doesn't impose scores of employees and a big budget in the realisation of his fantasies, but puts them together himself, painstakingly and by hand, which makes his delight in such egotists slightly comic. The lack of fit between the subtitled account of the excavations and the images will be visible to any viewer, whether they can identify any of the actual places filmed or not; this is a tribute, and a stimulus to the imagination rather than a lesson.

The Emperor's vision is certainly worth thinking about; indeed there is some lively scholarship on this period on the relationship between cosmology and Qin achievements in political control and bureaucracy[1]. On the aesthetic and technological front, even if it's not true that the terracotta warriors were modelled from individuals, as has often been said, they are cleverly varied from standardised parts. The ambition even to vary them makes this particular autocrat's power and fear of death more aesthetically appealing and perhaps more politically complex than that of Ancient Egyptian priests and kings; because everything and everyone in the state of Qin did depend on the Emperor's body at the centre, and the system did indeed fall apart after his death. But maybe that's not the point. What is slightly

1. Robin D.S. Yates, 'Boundary Creation and Control Mechanisms in Early China', in *Boundaries in China* ed. John Hay (London: Reaktion Books, 1994).

odd is Wilcox's idea of making some kind of *tribute* to the Emperor. Even the most excited documentaries don't allow unalloyed wonder. It is this that perhaps makes Wilcox's work resemble that of the artist Joseph Cornell more closely than it does other artists or film-makers; it is about the strangeness of what thoughts are released when one starts to let something like fan-worship apply itself to unorthodox objects. Of course Cornell also made the first experimental film from appropriated footage: *Rose Hobart*, in 1936.

The underlying aspect of tribute in Wilcox's film explains the moments in it which reach beyond documentary and playfulness for an actual imagination of the Emperor's death. As in the Marie-Antoinette film, we find to our surprise that we start to take this representation of death seriously. Borrowed footage shows the Emperor's face, heavily made up, at the point of death. 'The Emperor died in 210 B.C. on a tour of the Eastern provinces while searching for an elixir of immortality.' It is at this point that something interesting happens: we are not able to understand what follows or quite manage our response. We cut to a shot of white-clad figures, surrounded by white banners of mourning, but *running*. 'Don't leave!' read the subtitles. The show of grief is interrupted by the captioned commentary, which informs us that the architects and artisans of the tomb, as well as the Emperor's childless concubines, followed him into it. Then we get to see the two running mourners again. Around them are exploding discs, that fill the air and miraculously vanish. It is a sight not possible to understand, even in the still from the film Wilcox has isolated for us and framed up, its optically encoded soundtrack visible along one side. The supernatural discs clearly had an origin in something that the camera actually recorded, but what? The screen darkens, we seem to be underneath something – perhaps a tomb lid – and then sunlight appears and dazzles the camera. The mourners reappear. One falls to the ground to beat on it and her black shoes briefly lift into the air behind her.

This sequence is from *Ju Dou* (Zhang Yimou, 1990). It has Gong Li, in an extraordinary setting. Shot almost entirely in a small town dyeworks of the 1920s, it is the kind of simple story that makes a surprisingly complex film. The mourning scene itself has dark ironies that are not relevant to Wilcox's use of it. The mourners are surrounded by discs of simple paper, cast by one of the funeral party, they are running because it is their ritual duty to try to stop the funeral procession. The darkness in the shot is the moment when the cart passes over them. All this both is and isn't relevant to the emotional pressure and surprise of the slowed shots as re-used in *The Death and Burial of the First Emperor of China*. They have a meaning in Wilcox's appropriation that is particular to it alone.

After this sequence, the account proceeds to the interior of the tomb and its cosmology; its relief map of all China and fantastic waterways of mercury mapped on the rivers and canals, on which the Emperor's boat will sail forever. Wilcox's animation completes this homage, or souvenir of the Emperor. Shot through layers

of glass, it shows a hand-drawn sea in a Chinese stylisation, a boat bearing a white flag of mourning, and the Emperor's body, in a suit of jade, against a collage of pagodas, steep green hills and a backdrop from a scroll painting. A slow orientalist pop song plays, which some will recognise as 'Canton' by Japan. The dramatic interruptions show the violent movements of a rower; there is a delay before we can identify the action as rowing, and it is a surprise to work out that the lighting must be a slowed down filmic lightning bolt.

The final sequence, Wilcox's footage of a sky-blue rococco building, with tourists walking past, accompanies the description of the tests by the Chinese Institute of Science that indicate high levels of mercury in the burial mound itself. And in a final hint of mystery, it is stated that now the ancient descriptions of the tomb's interior are regarded as plausible, 'booby traps must be anticipated'. We are looking at the Chinese teahouse from Sanssouci, Frederick the Great's Palace at Potsdam; but it is enjoyable that we can be ever so slightly fooled for a moment.

Stephen Tennant Homage (1998)

His most recent film is a short evocation of Stephen Tennant, a character famous for being himself, who required the full apparatus of a contemporary biography (Stephen Hoare's *Serious Pleasures*) to effect a real gain in historical substantiality. The house sale after his death, mentioned in the film, was probably one of his better-known achievements. Stephen Tennant was from a world where people still used the phrase 'covered with embarrassment', and sometimes, possibly, felt it. Djuna Barnes better captured the strangeness of the 1920s, and the poems of Frank O'Hara are a better guide to changing your life; but Tennant's humour, as revealed by the drawings shown in the film, was at least intentional. A printed caption shown reads 'Next Gentleman, Please',

Wilcox's homage to Tennant is actually rather disarming and modest. It is in part a recreation of Tennant's country house as Wilcox imagines it. The film is structured around a repeated ascent and descent of spiral stairs (to Stephen's bedroom) by someone of whom all we see is rather ravishing white-painted toenails. The stairs are decorated with shells and starfish, fishing nets and fans. Intercut with this are slowed sections from Fassbinder's *Querelle* (1982), to evoke the novel of port life Tennant never completed. There is real cruisy eroticism, and also disappointment here; and a fantastic moment from the balletic fight sequence, in which two figures grapple and dance, knives raised. The film also includes a single female role, played by Jeanne Moreau. But the two attempts at port life – Tennant's jolly, occasionally tender drawings, Fassbinder's violent stylisation and saturated colour – succeed by their air of unreality in drawing attention to the strongly documentary soundtrack Wilcox made for the film. It records the silence in rooms in which not much is being said; the hesitations, the sound of an incomplete character being incompletely remembered. There is a section where

for a long, long time the camera rests on the model Stella Tennant, impersonating her great uncle's epic ability to stay in bed. Wilcox's tentative questions to her, heard earlier in the film, have for the moment petered out, as have her reminiscences, but the distant sound of some old slow jazz being played in another room can be heard. It's Billie Holiday's voice.

None of the soundtrack is synched to any of the film we see. Indeed, a clapperboard is shut silently in front of the figure in the bed to prove the point. And for all the talk of the traces of Stephen Tennant in this film (his scent permeating the house after his death, for example, which spooked the builders (it is the seemingly accidental inclusion of a singer's voice that becomes one of the most evocative things in it, a kind of incursion of some of the other histories that this particular homage can't detail.

'The End'

In a poem called *To the Film Industry in Crisis* Frank O'Hara wrote that 'In times of crisis, we must all decide again and again whom we love'. It's one of the provocations offered by T.J. Wilcox that his films grow out of a love of films and an old-fashioned taste in artifice which is miles from the tired amazement of contemporary special effects. They celebrate the fact that you can say that a film is about an Emperor or a Queen and that the audience will play along. They are also celebrations of the pre-digital imagination, right down to the sound made by the projector, which is part of the show. Video and electronic distribution is another matter. At 33, Wilcox is from the generation that learnt that film could be replayed and 'owned' in a new way. It's an industrial development that has had a hugely beneficial impact on how we are able to know and also debate what we want from film, and trade competitive lists.

The results? They are signed works (innocent of even a copyright symbol), craft productions for intimate showings; trailers for strange bits of the past that may be jewels or may be fading out of view. They pay fond homage to narrative pleasure with that closing sign, 'The End' and their apparent biographical focus; but the habits of attention they receive in a gallery are other than a simple wish for narrative or an easily storied past, (at least those stories of 'How Art Reminds Film What Else It Can Do', which are many: film as still life, as portrait, as poem or just as what happens when the camera gets switched on). It is in that close attention that the films generate that their ability to surprise - and to catch us out, wanting something - is to be found.

Interview
by Douglas Fogle

DF: How did you come to film as your medium of choice?
T.J. W: I was attracted to how complex and layered film can be and how dense the images that you're able to construct can be within this very ephemeral medium, which is essentially just light and colour. I was also attracted to its sculptural presence within the gallery context.

Film can invoke, even from the moment you see the projector and the screen, a kind of fantasy space. As soon as the lights go down and the projector starts, we enter into the space of another reality. In my work I'm preoccupied by different narratives or fantasy spaces. Film goes there by its very nature so it's a useful medium for the different subjects I want to explore.

Your first two films deal with interpretations of two very different historical figures – Marie Antoinette and the First Emperor of China – but in a certain way they both play with the idea of history as storytelling.
The subject of *The Escape (of Marie Antoinette)* was Marie's attempt to escape during the French Revolution. The royal family was under house arrest and their movements were very controlled but Marie started covertly planning their escape from the palace and secretly had a carriage constructed. As Marie got more and more immersed in the idea of this escape it became not just about the actual act of escaping, but about how she was going to effect this escape. The carriage that she was designing got more elaborate as her plans became more and more baroque. Finally, it became so ornate, heavy, and full of creature comforts that they didn't get very far before they were caught because they were forced to travel at such a slow pace. The story is usually told as a morality tale about the excessive nature of the monarchy and its inevitable end. I wasn't interested in retelling that as a morality tale; I was interested in glorifying Marie's complete immersion in her own fantasy construction around her escape.

The actual process you use to make your films is quite unique. How does this idea of layering fit into your film technique?

I film everything on Super-8 film whether I'm appropriating video or film material off of monitors, or making my own animated scenes. I then transfer it to video for editing, which I then transfer back to 16mm film to project in the gallery. This process of transferring from film to video to film gives the works a very specific look or an uncommon palate because the image shifts with each transfer.

At the labs they think I'm losing image but I always feel like I'm gaining something new with each step in the process. I became interested in this accumulating aspect of the process and this surplus of work that had a spectacular beauty as its result. I felt that there was a correlation between my formal process and the process that Marie Antoinette went through. I love this immense amount of labour that's expended on something as ephemeral or fleeting as fantasy. Marie Antoinette's carriage became an elaborate manifestation of her own ideas or fantasies of escape. It was an attempt to pin fantasy down, to give it a physical presence in the world. I really admire that and my films pay homage to that sort of project.

What attracted you to the subject of your second film, *The Death and Burial of the First Emperor of China*?

In the 1970s the tomb of the First Emperor of China was discovered by villagers who were digging a well. He died around 200 B.C. and the story of his life, death, and burial has been repeated ever since. Whenever I read about this tomb, the story would always end with a discussion of the "enigma" of the emperor's tomb, which fascinated me. The legend suggests that the emperor tried to re-create his own universe, as he understood it, inside this tomb so that he would be able to eternally fix the world and his place within it. The ceiling of this tomb was supposedly painted with all of the constellations as the Chinese astronomers understood them. The floor of the tomb was a complete relief map of China with all the major mountains and valleys through which flowed rivers of mercury. The body of the Emperor himself was supposedly placed on a boat and set assail to float down one of these rivers eternally.

I was completely captivated by this legend. In my film I wanted to go into this tomb, which of course I couldn't really do, so I had to lay the groundwork for bringing the viewers to the tomb with me metaphorically so that we could go inside. I love to see how I can get to these places with my own modest filmic means. For example, the film begins at Mann's Chinese Theater in Los Angeles, which is part of the world that I inhabit. In my tomb, the ceiling with all the constellations becomes the newly cleaned ceiling at Grand Central Station in New York City. The mountains and valleys are seen in an animated sequence that I constructed myself, which was collaged from Chinese paintings, photographs, and drawings. The emperor becomes Donald Sutherland as seen in the film Fellini's *Casanova*, 1976.

Why that film in particular? It seems to have very little to do with China.

Our memory plays strange tricks on us when we remember some films. My principle memory of Fellini's *Casanova* was a scene of Casanova rowing his boat across this sea. I hadn't seen it for a long time and I was shocked on watching it again to discover that this rowing sequence takes up only seconds of the film, while in my memory it was a major scene.

My films give me an excuse to collage or bring together bits of visual information that I personally can't get rid of and put them together in this kind of accumulation. I'm interested in encouraging viewers to assemble their own readings from the given material.

Your new project, *Stephen Tennant Homage*, takes on another historical figure. Will your approach to this figure be similar to Marie Antoinette or the First Emperor of China?

It is a little different. Stephen Tennant was an artist, author, and one of "The Bright Young Things" of the 1920s. He was a very wealthy British heir who became the muse of many, but whose life wasn't substantiated by tangible or completed projects. In our culture where we fetishise work, Tennant aspired to a kind of unproductivity that relegated him (to some) to the dustbin of foppishness. I wanted to make a film that championed him as an ideal of another possible way of living or thinking about productivity. I wanted to pay tribute to this person whose life was really devoted to the ephemeral.

Will the narrative of this film be just as loose as your first two films?

The narrative has to be very loose and unstructured because the subject is Stephen Tennant. Essentially I understand the film as entering into his house as I have imagined it. Once again, I am obviously not going into Stephen Tennant's actual house but I'm rather imagining a passage into Stephen's domain that was in part dominated by the major preoccupation of his life: his unfinished novel *Lascar*, which he worked on for 40 years.

Do you see the figures in these three films as romantically tragic?

I don't think of them as tragic at all. I think that they are all great champions of their own particularised desire.

Would you ever want to make films outside of the gallery context?

In the end, I'm attracted to the audience who would come and see a film in an art gallery. The gallery holds a very unique place in contemporary life that shouldn't be squandered. There aren't that many places left where we are encouraged to think and that's an opportunity that I like to take advantage of.

Minneapolis, USA. 1 February 1998

Originally published in conjunction with the exhibition Dialogues: Sam Easterson/T.J. Wilcox, *Walker Art Center, Minneapolis, USA, 4 April – 28 June 1998*

Stephen Tennant Homage (1998)

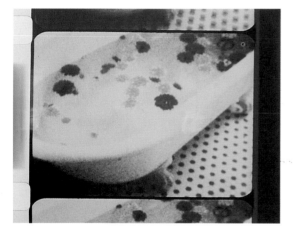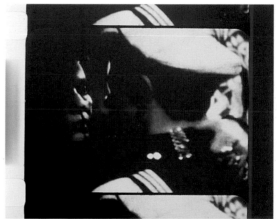

Photograph of the
film *Stephen Tennant
Homage*, 1998, No 2
R-Print 16" x 20"

Photograph of the
film *Stephen Tennant
Homage*, 1998, No 3
R-Print 16" x 20"

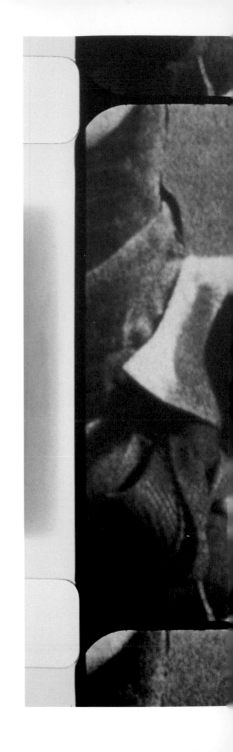

Photograph of the
film *Stephen Tennant
Homage*, 1998, No 4
R-Print 16″ x 20″

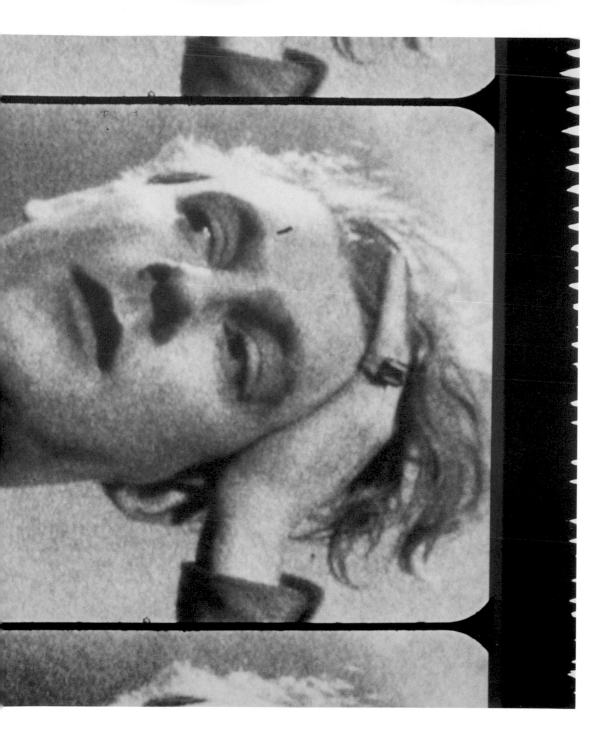

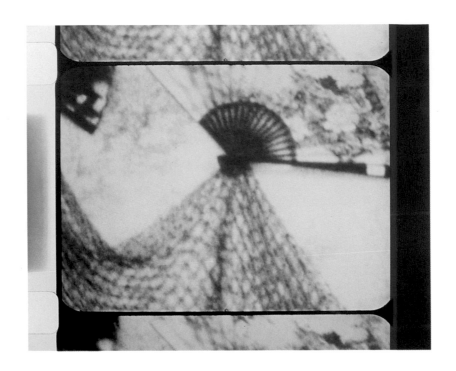

Photograph of the
film *Stephen Tennant
Homage*, 1998, No 5
R-Print 16" x 20"

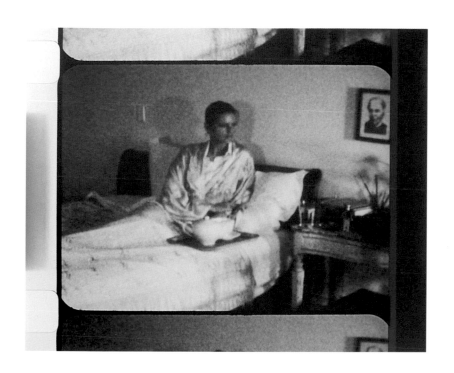

Photograph of the
film *Stephen Tennant
Homage*, 1998, No 6
R-Print 16″ x 20″

The Death and Burial of the
First Emperor of China (1997)

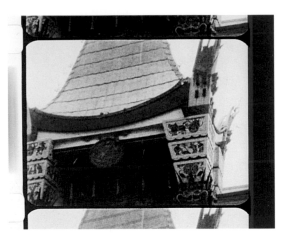 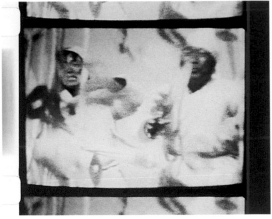

Photograph of the film
*The Death and Burial
of the First Emperor
of China,* 1997, No 1
R-Print 16" x 20"

Photograph of the film
*The Death and Burial
of the First Emperor
of China,* 1997, No 3
R-Print 16" x 20"

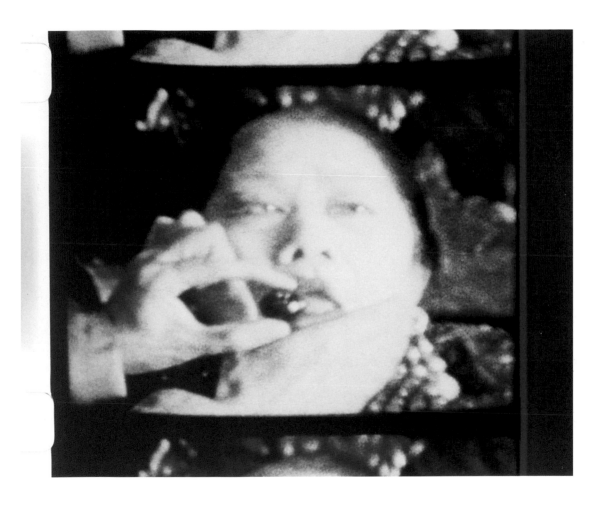

Photograph of the film
The Death and Burial
of the First Emperor
of China, 1997, No 2
R-Print 16" x 20"

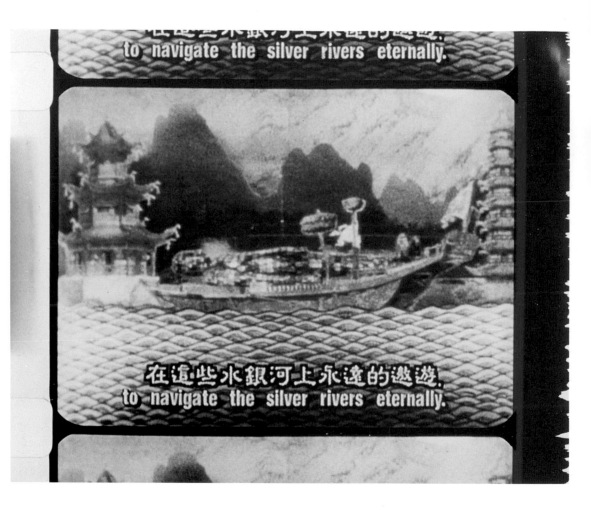

Photograph of the film
*The Death and Burial
of the First Emperor
of China*, 1997, No 6
R-Print 16" x 20"

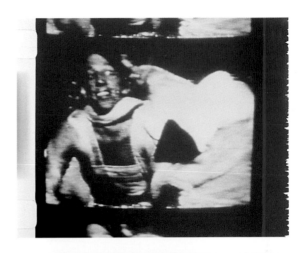

Photograph of the film
*The Death and Burial
of the First Emperor
of China*, 1997, No 5
R-Print 16" x 20"

Photograph of the film
*The Death and Burial
of the First Emperor
of China*, 1997, No 4
R-Print 16" x 20"

The Escape (of Marie Antoinette) (1996)

Photograph of the film
*The Escape (of Marie
Antoinette),* 1996, No 3
R-Print 16" x 20"

Photograph of the film
*The Escape (of Marie
Antoinette),* 1996, No 2
R-Print 16" x 20"

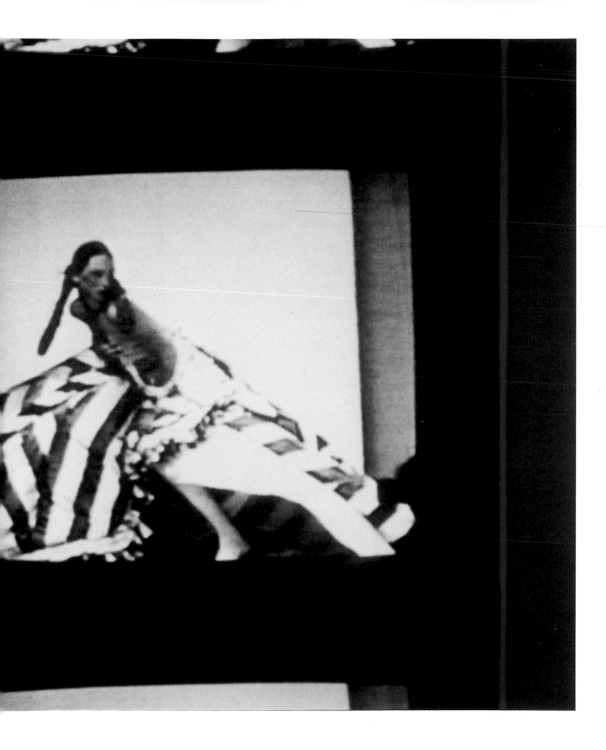

Photograph of the film
*The Escape (of Marie
Antoinette)*, 1996, No 1
R-Print 16" x 20"

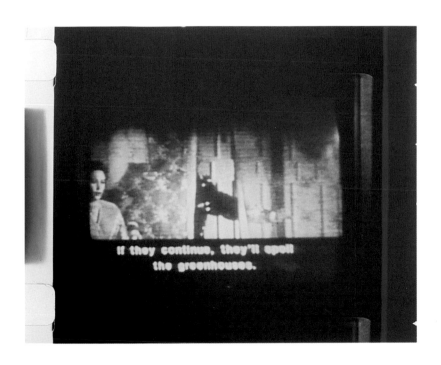

Photograph of the film
*The Escape (of Marie
Antoinette)*, 1996, No 4
R-Print 16" x 20"

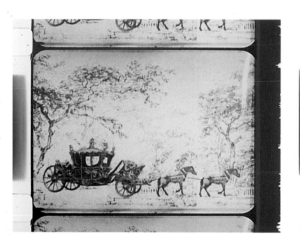

Photograph of the film
*The Escape (of Marie
Antoinette)*, 1996, No 5
R-Print 16" x 20"

Photograph of the film
*The Escape (of Marie
Antoinette)*, 1996, No 7
R-Print 16" x 20"

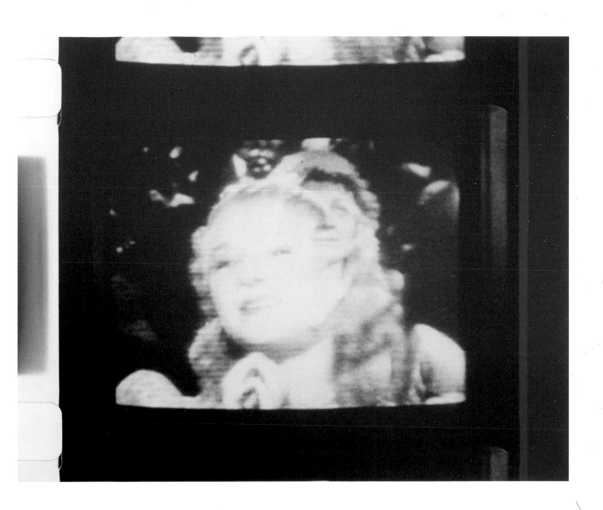

Photograph of the film
*The Escape (of Marie
Antoinette)*, 1996, No 6
R-Print 16" x 20"

Biography

Born Seattle, 1965
Lives and works in New York.

EDUCATION
1985-89 School of Visual Arts,
New York, BFA.
1993-95 Art Center College
of Design, Pasadena CA, MFA.

EXHIBITIONS
1998 *El Niño*, Museum Abteiberg,
Mönchengladbach, Germany;
Flaming June, Works on Paper,
Inc, Los Angeles; Institute of
Contemporary Arts, London;
Dialogues, Walker Art Centre,
Minneapolis.
1997 Daniel Buchholz, Cologne,
Germany; Gavin Brown's enterprise,
New York; Venice Biennale;
*Sunshine and Noir, Art in Los
Angeles, 1960-1997*, Louisiana
Museum of Art, Denmark (toured to:
Kunstmuseum Wolfsburg, Germany;
Castello di Rivoli, Italy; UCLA at The
Armand Hammer Museum of Art,
Los Angeles); The Whitney Biennial,
Whitney Museum of American Art,
New York.

1996 *Studio 246*, Marc Foxx Gallery,
Los Angeles; *Hollywood*, LACE, Los
Angeles; Los Angeles Center for
Photographic Studies,
Los Angeles; Gavin Brown's
enterprise, New York; *Persona*,
Kunsthalle, Basel, Switzerland;
Affairs, The Institute for
Contemporary Art Vienna, Austria;
Studio 246, Kunstlerhaus
Bethanien; Berlin, Germany;
Sampler II, David Zwirner Gallery,
New York; *Contemporary
Collections*, L.A.C.P.S., Los Angeles.
1995 Art Center College of Design,
Pasadena, CA; *The Big Night*,
Bradbury Building, Los Angeles;
Fabrication, The Guggenheim
Gallery, Chapman University,
Orange, CA.